Desiree –
You are a great
thirty, flirty, thriving
teacher! Happy Birthday.

Lynn

st enter by yourself *Chinese proverb* the
grow where only one g
e an atmosphere of awe and walk
being himself
party, a company by the way,
y Ward Beecher a good book is the best of
Tupper children are made readers or
everyone and everything around you
been for me, for as long as I car
iration, adventure, and delight;
Anderson the excitement of learning
as you're learning, you're not ol
nto the world of thought—that is to
s the province of the student: it is
t is a wide field full of beckoning

# Words

## FOR TEACHERS TO LIVE BY

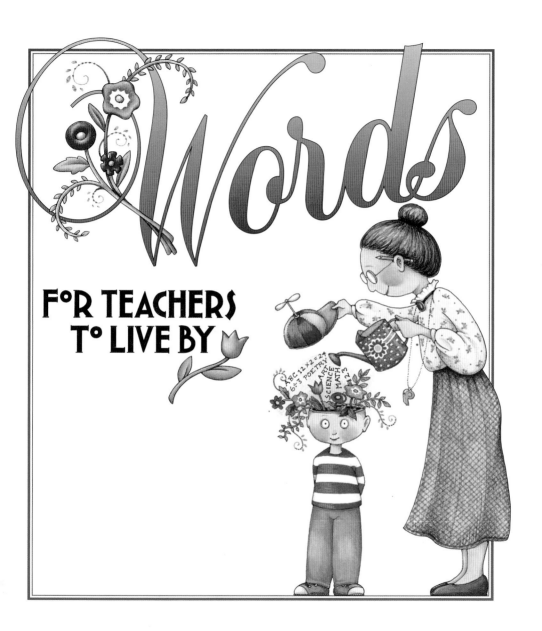

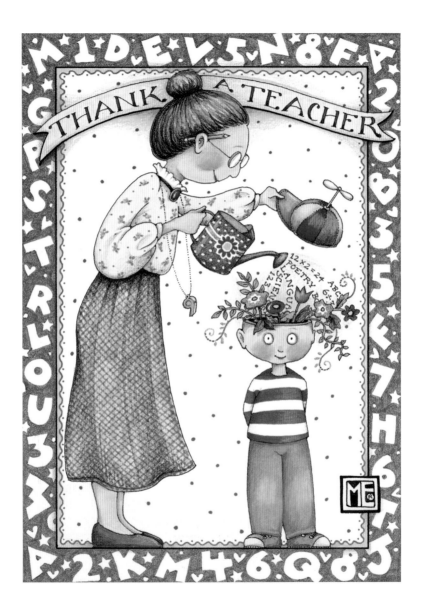

# Words

## FºR TEACHERS Tº LIVE BY

illustrated by Mary Engelbreit

**Andrews McMeel
Publishing**

Kansas City

www.andrewsmcmeel.com
www.maryengelbreit.com

 and Mary Engelbreit are registered trademarks of Mary Engelbreit Enterprises, Inc.

Words for teachers to live by / illustrated by Mary Engelbreit.
  p. cm.
 ISBN 0-7407-2086-4
 1. Education--Quotations, maxims, etc. 2. Teaching--Quotations, maxims, etc. I. Engelbreit, Mary.

PN6084.E38 W67 2002
370--dc21

2001045908

02 03 04 05 06 MON 10 9 8 7 6 5 4 3 2 1

*Illustrations by Mary Engelbreit*
*Design by Stephanie R. Farley and Delsie Chambon*

# Contents

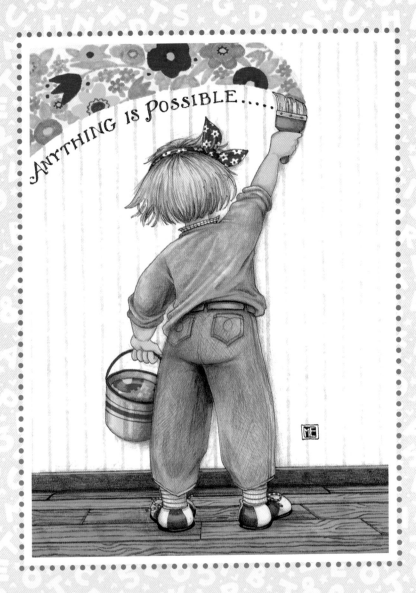

# A few Words... from Mary Engelbreit

I remember so clearly how much I loved going to school when I was a little girl (and, yes, I admit my enthusiasm did wane a bit in the later years). The friends, the classrooms, the cute and tidy Catholic school uniforms—it was all so new and exciting! But best of all were the books.

My lifelong love affair with books began on my mother's lap as I followed along with the antique storybooks she read to me as a child, but it reached full bloom when I learned to read on my own. The world of books was a paradise to me, and teachers held the key to the gate. Through books, and thus through teachers, I learned that anything was possible. (In fact, it was my passion for reading that ultimately led me to a career as an artist—I wanted to draw pictures to go along with the stories that I read.)

How many people's work has the power to affect the lives of hundreds—even thousands—of others? For teachers, this is most certainly the case. Good teachers do so much more than shepherd their charges through lesson after lesson. They challenge young imaginations and instill in children a lifelong passion for learning.

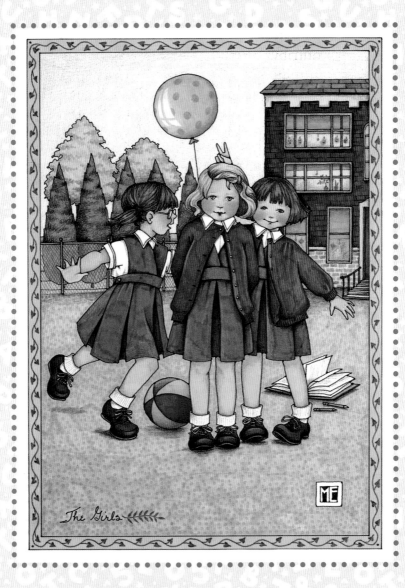

The Girls

And, of course, good teachers aren't found only in the classroom. Parents, siblings, mentors, and friends all contribute to the full development of young minds. Even nature itself can be a powerful teacher. As long as a student is willing, learning never stops.

Because of my strong memories of early school days and my tremendous respect for the work teachers do every day, teachers (and school children too, of course) are frequently the subjects of my drawings. I guess it's my little way of showing appreciation for a severely under-appreciated group.

If the work of teachers has inspired me over the years, I am certainly not alone. Down through history, writers, artists, scholars, statesmen, and students have all paid tribute to the practitioners of this most noble profession. In this book, I've combined many of their wonderful words about teachers with some of my own favorite drawings.

The art and the words may say it in different ways, but the message is always the same: teachers touch us all—and for this we should be truly grateful.

Mary

eachers open the door, but you must enter by yourself Chinese proverb th eacher is one who makes two idea grow where only one grew befor Elbert Hubbard a ... ter shoul have an atr... of awe, an walk wonde... if he wa amazed ... being himself Walter Bagel he teacher is no longer merely the ne-who-teaches, but the one wh s himself taught in dialogue wit he students, who in turn whil eing taught also teach Paulo Freire W each what we need to learn Glo the best that the great teache

**LEARN AND LIVE**

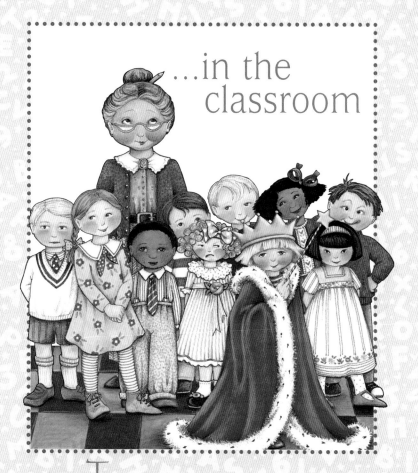

## ...in the classroom

Teaching is the royal road to learning.
—Jessamyn West

There is
no more beautiful life
than that of a student.
—F. Albrecht

What was the duty
of the teacher
if not to inspire?
—Bharati Mukherjee

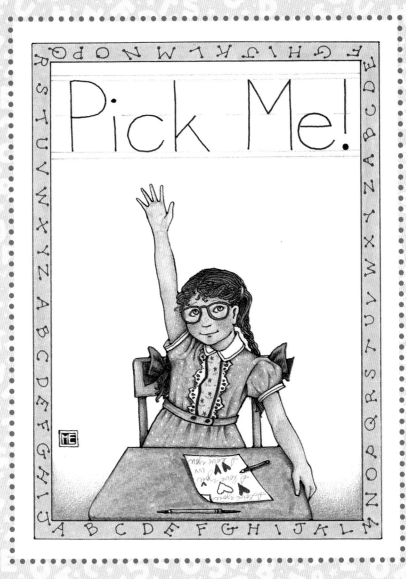

Teachers provide a social
and intellectual environment
   in which students can learn.
      —James MacGregor Burns

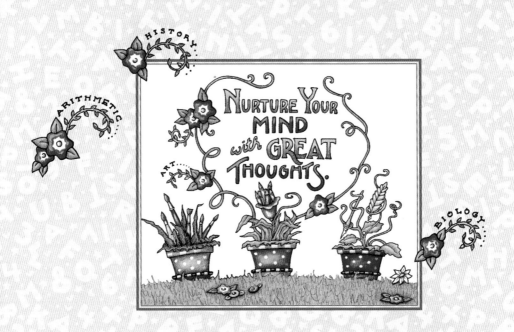

NURTURE YOUR MIND with GREAT THOUGHTS.

HISTORY

ARITHMETIC

ART

BIOLOGY

READING

It is the supreme art of the teacher
    to awaken joy in creative expression
        and knowledge.
                    –Albert Einstein

GROW WHAT YOU KNOW...

The teacher is one
who makes two ideas grow
where only one grew before.
—Elbert Hubbard

We learn by teaching.
—James Howell

To teach is to learn twice.
—Joseph Joubert

The greatest sign of success
for a teacher...is to be able to say,
"The children are now working
as if I did not exist."
–Maria Montessori

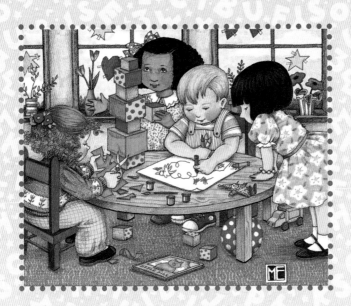

A schoolmaster should have
an atmosphere of awe,
and walk wonderingly,
as if he was amazed at being himself.
—Walter Bagehot

All new knowledge gladdens the teacher
only to the extent that he can teach it.
—Friedrich Nietzsche

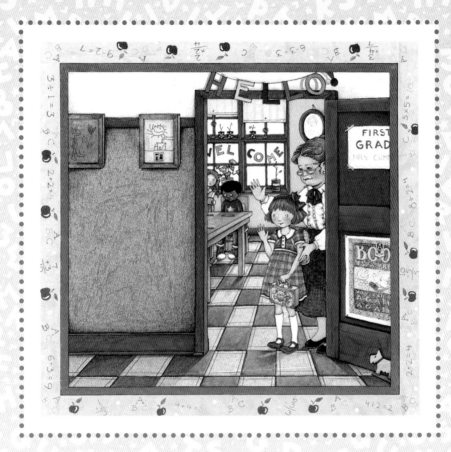

Teachers open the door,
but you must enter by yourself.
—Chinese proverb

A school should not be a preparation for life.
A school should be life.

–Elbert Hubbard

Merry have we met and
Merry have we been;
Merry let us part and
Merry meet again!

All acts
performed in the world
begin in the imagination.
–Barbara Grizzuti Harrison

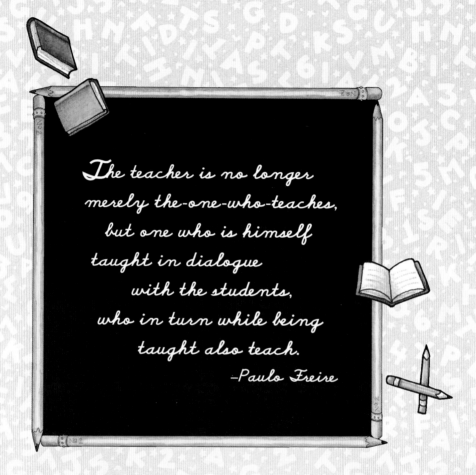

The teacher is no longer
merely the-one-who-teaches,
but one who is himself
taught in dialogue
with the students,
who in turn while being
taught also teach.

—Paulo Freire

We teach what we need to learn.

—Gloria Steinem

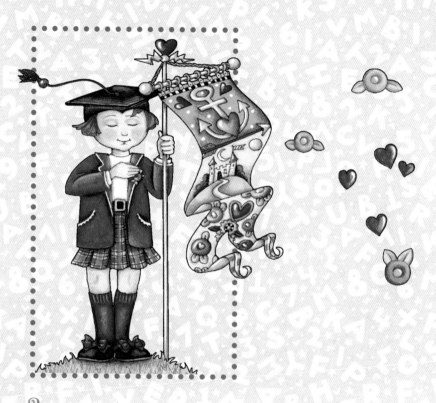

The best that the great teachers can do for us
is to help us to discover what is already present in ourselves.

—Irving Babbitt

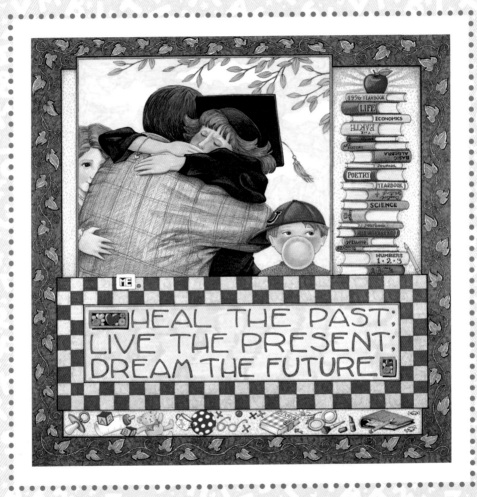

HEAL THE PAST;
LIVE THE PRESENT;
DREAM THE FUTURE.

Successful teachers
are surpassed by their pupils.

—anonymous

A teacher affects eternity;
he can never tell
where his influence stops.

—Henry Adams

MISS
SMARTY

Intelligence plus character—
that is the goal of true education.

—Gloria Steinem

The task of a teacher
is not to work for the pupil
nor to oblige him to work,
but to show him how to work.

—Wanda Landowska

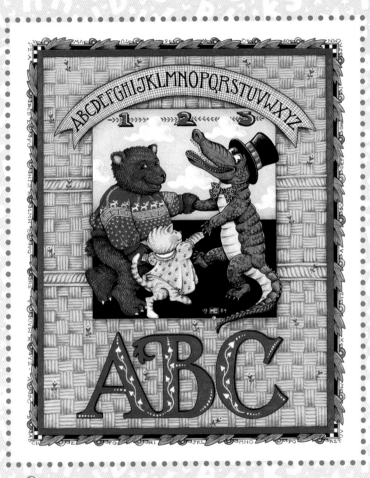

Happiness lies in the joy of achievement
and the thrill of creative effort.
—Franklin D. Roosevelt

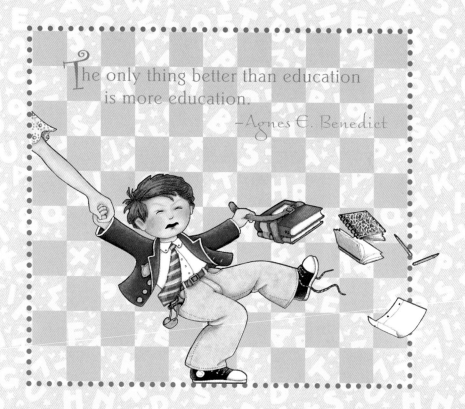

The only thing better than education
is more education.

—Agnes E. Benedict

no entertainment is so cheap as
reading, nor any pleasure so lasting
*Wortley Montague* children are made readers
on the laps of their parents *Emilie Buchwald*
to feel most fully alive means
to be reading beautiful
ready always to lend in the
flow of language the sudden flash of
poetry *Gaston Bachelard* a book is a garden,
and orchard, a storehouse, a party,
company by the way, a counselor, a
multitude of counselors *Henry Ward Beecher*
we are made whole by books, as b
great spaces and the stars *Mary Caro*
a good book is the best

**LEARN**
**A·N·D**
**LIVE**

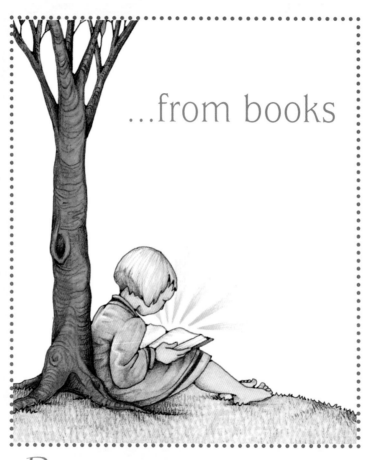

...from books

Reading is the basic tool in the living of a good life.
– Mortimer J. Adler

The greatest gift is the passion for reading.
It is cheap, it distracts, it excites,
it gives you knowledge of the world
and experience of a wide kind.
It is a moral illumination.
—Elizabeth Hardwick

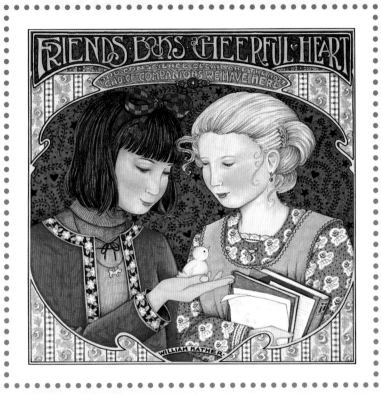

It is important to use all knowledge
ethically, humanely, and lovingly.
–Carol Pearson

Try to learn something about everything
and everything about something.
–Thomas H. Huxley

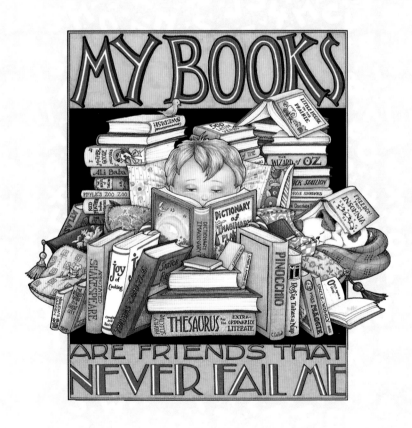

He that loves a book
will never want
a faithful friend,
a wholesome counselor,
a cheerful companion,
an effectual comforter.
By study, by reading,
by thinking, one may
innocently divert and
pleasantly entertain himself,
as in all weathers,
as in all fortunes.
—Barrow

A BOOK IS A PRESENT YOU CAN OPEN AGAIN AND AGAIN

Read in order to live.
–Gustave Flaubert

When I only begin to read,
I forget I'm on this world.
It lifts me on wings with high thoughts.
–Anzia Yezierska

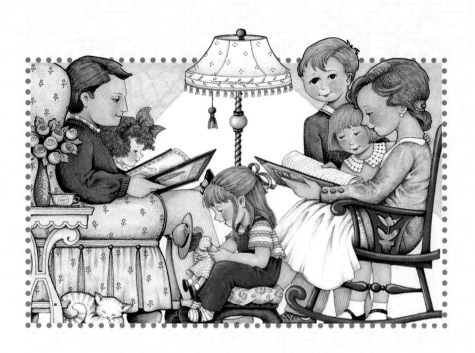

Children are made readers
on the laps of their parents.

–Emilie Buchwald

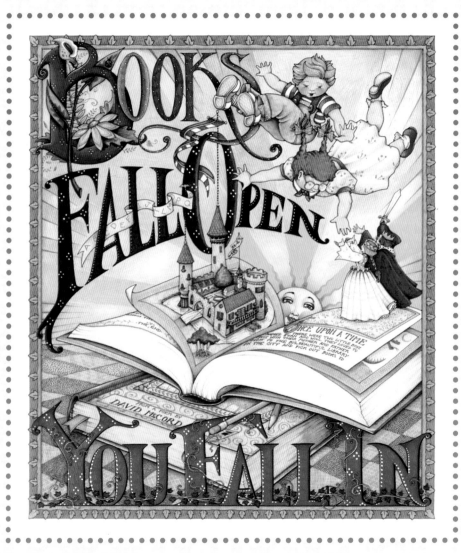

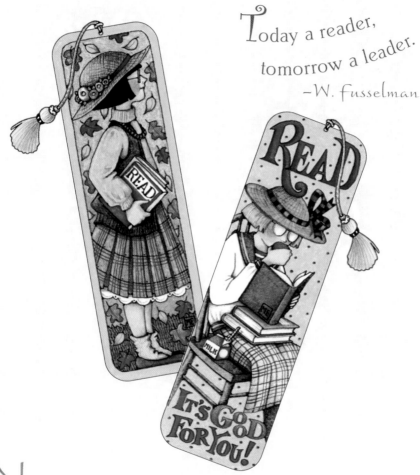

Today a reader,
tomorrow a leader.
—W. Fusselman

No entertainment is so cheap as reading,
nor any pleasure so lasting.
—Wortley Montague

41

We are made whole by books,
as by great spaces
and the stars.
—Mary Carolyn Dewies

A book is a garden,
an orchard,
a storehouse,
a party,
a company by the way,
a counselor,
a multitude of counselors.
—Henry Ward Beecher

We have a hunger for the mind
which asks for knowledge of all around us,
and the more we gain,
the more is our desire;
the more we see,
the more we are capable of seeing.

—Maria Mitchell

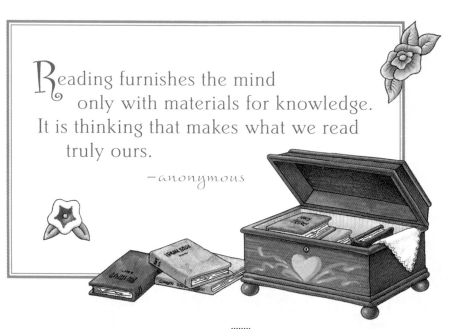

Reading furnishes the mind
only with materials for knowledge.
It is thinking that makes what we read
truly ours.

—anonymous

I think you should learn, of course,
and some days you must learn a great deal.
But you should also have days
when you allow what is already in you
to swell up inside of you
until it touches everything.
And you can feel it inside you.
–E.L. Konigsburg

THE LOVE of LEARNING, THE SEQUESTERED NOOKS, AND ALL THE SWEET SERENITY of BOOKS

-LONGFELLOW-

That is what learning is.
You suddenly understand something
you've understood all your life,
but in a new way.

–Doris Lessing

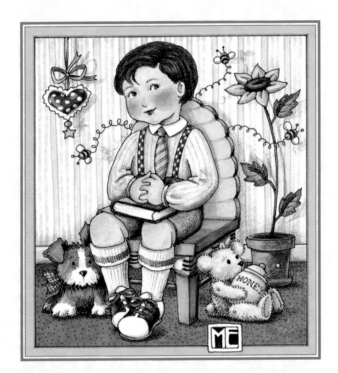

Learning makes a man fit company for himself.
—Thomas Fuller

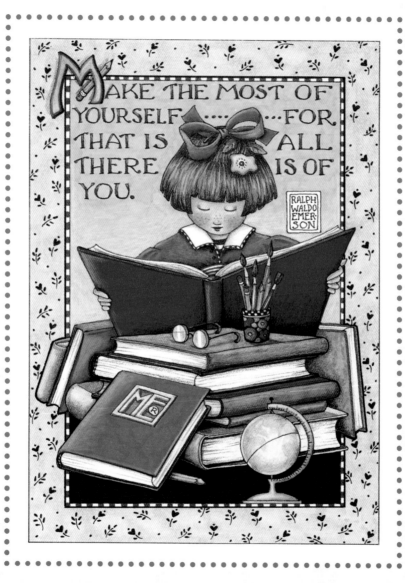

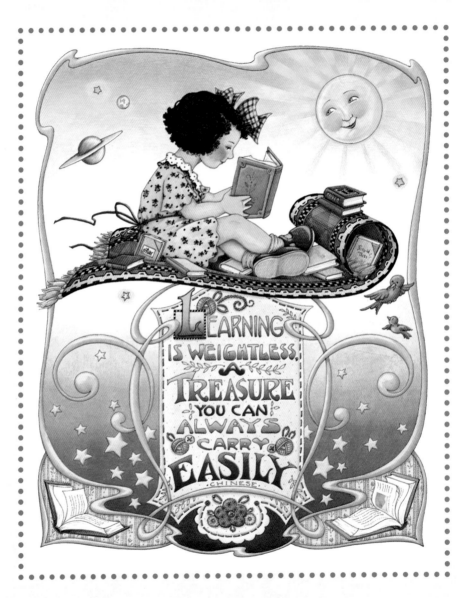

There are books so alive
that you're always afraid
that while you weren't reading,
the book has gone and changed,
has shifted like a river;
while you went on living,
it went on living too,
and like a river moved on and moved away.
No one has stepped twice into the same river.
But did anyone ever step twice
into the same book?

—Marina Tsvetaeva

When we read a story
we inhabit it.
The covers of the book are like
a roof and four walls.
What is to happen next will
take place within the four walls
of the story. And this is possible
because the story's voice
makes everything its own.
–John Berger

To feel most beautifully alive
means to be reading
something beautiful,
ready always to comprehend
in the flow of language
the sudden flash of poetry.
–Gaston Bachelard

everyone and everything around you is your teacher Ken Keyes, Jr. nature has been for me, for as long as I can remember, a source of solace, inspiration, adventure, and delight, a home, a teacher, a companion Lorraine Anderson learning how to learn is life's most important skill Tony Buzan the important thing is not so much that every child should be taught, as that every child should be given the wish to learn John Lubbock the unknown is the province of the student: it is the field for his life's adventure, and is a wide field full of beckoning

**LEARN AND LIVE**

...from nature

The art of teaching is the art of assisting discovery.
- Mark Van Doren

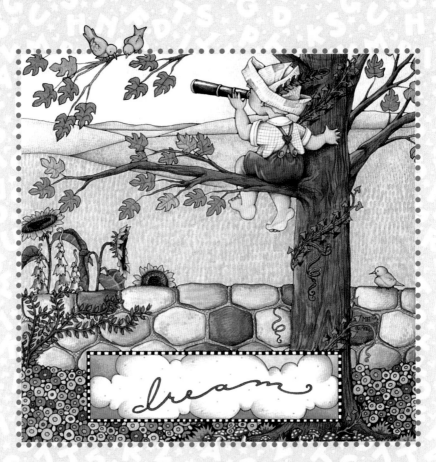

Most new discoveries
are suddenly-seen things
that were always there.
–Susanne K. Langer

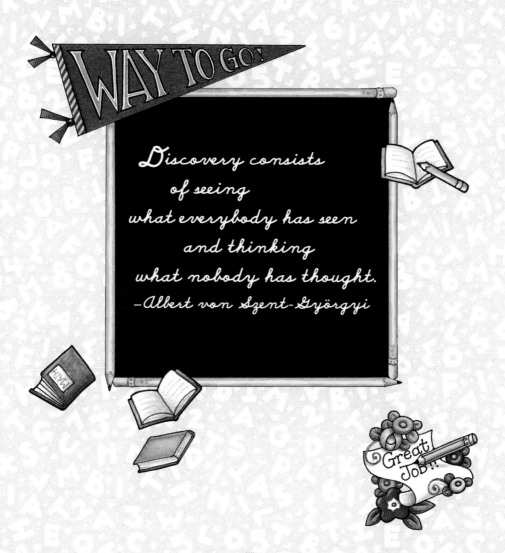

WAY TO GO!

Discovery consists
of seeing
what everybody has seen
and thinking
what nobody has thought.
—Albert von Szent-Györgyi

Great Job!!

Education should consist
of a series of enchantments,
each raising the individual
to a higher level of awareness,
understanding, and kinship
with all living things.

—anonymous

COME FORTH
INTO THE LIGHT
of THINGS,
LET NATURE
BE YOUR TEACHER
WILLIAM WORDSWORTH

# How we learn is what we learn.

—Bonnie Friedman

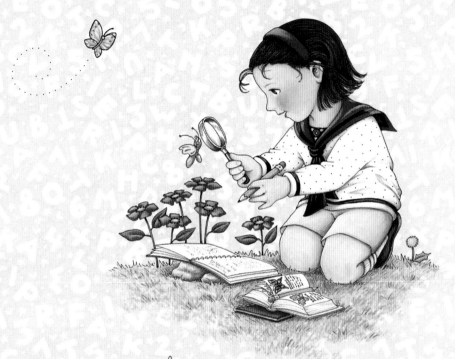

Learning how to learn
is life's most important skill.

—Tony Buzan

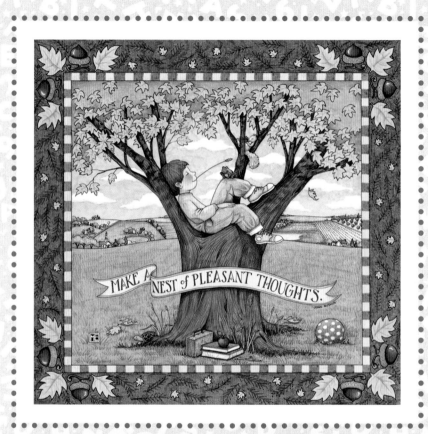

MAKE A NEST of PLEASANT THOUGHTS.

€ach day is the scholar of yesterday.
–Publilius Syrus

It made me gladsome to be getting some education,
it being like a big window opening.

—Mary Webb

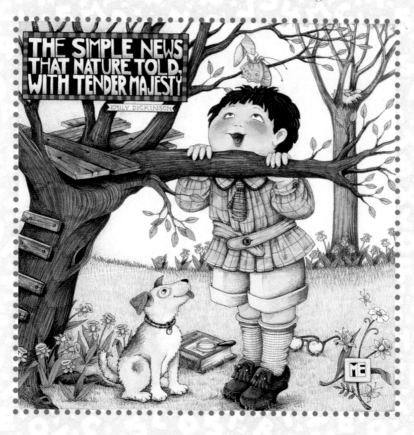

THE SIMPLE NEWS
THAT NATURE TOLD,
WITH TENDER MAJESTY

EMILY DICKINSON

Everyone and everything around you
is your teacher.

—Ken Keyes, Jr.

God wove a web of loveliness,
          of clouds and stars and birds,
but made not anything at all
          so beautiful as words.

–Anna Hempstead Branch

Nature has been for me,
     for as long
     as I can remember,
a source of solace,
inspiration, adventure,
     and delight;
          a home, a teacher,
a companion.

–Lorraine Anderson

What we learn to do, we learn by doing.

–Aristotle

The unknown is the province of the student:
it is the field for his life's adventure,
and it is a wide field full of beckonings.
—Lincoln Steffens

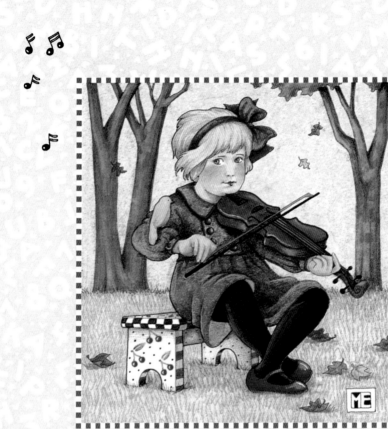

Learn one thing well first.

–John Clarke

The important thing is not so much
that every child should be taught,
as that every child should be given
the wish to learn.
—John Lubbock

Learn in order to teach and to practice.
—Talmud

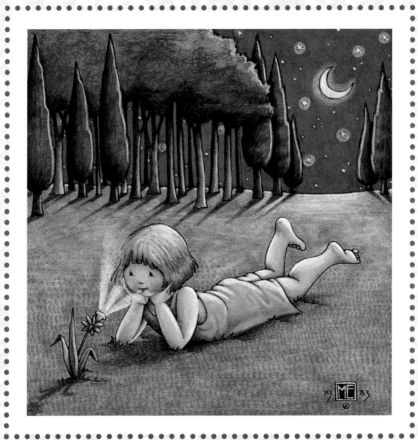

$\mathcal{E}$ducation is the power to think clearly,
the power to act well in the world's work,
and the power to appreciate life.
—Brigham Young

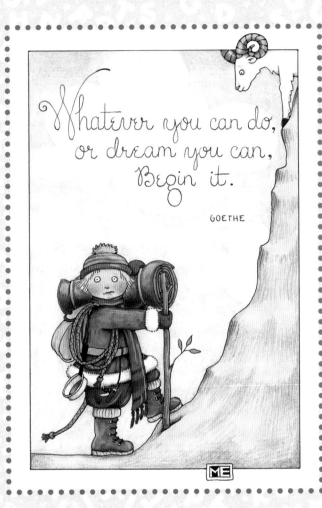

Whatever you can do,
or dream you can,
Begin it.

GOETHE

Skill to do comes of doing.
–Ralph Waldo Emerson

Life is a succession of lessons,
which must be lived to be understood.
–Ralph Waldo Emerson

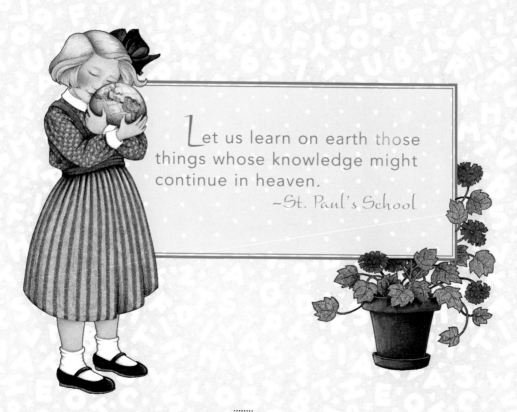

What we have learned from others
becomes our own by reflection.
–Ralph Waldo Emerson

Let us learn on earth those
things whose knowledge might
continue in heaven.
–St. Paul's School

Develop a passion for learning.
If you do, you will never cease to grow.
*—anonymous*

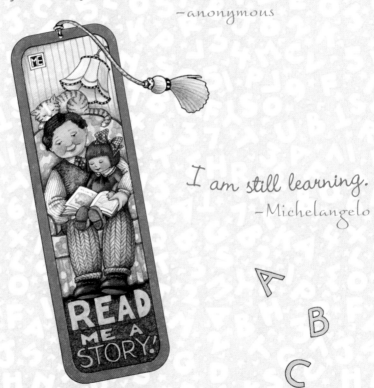

READ
ME A
STORY!

*I am still learning.*
—Michelangelo

A
B
C

Each day grow older,
and learn something.
—Solon

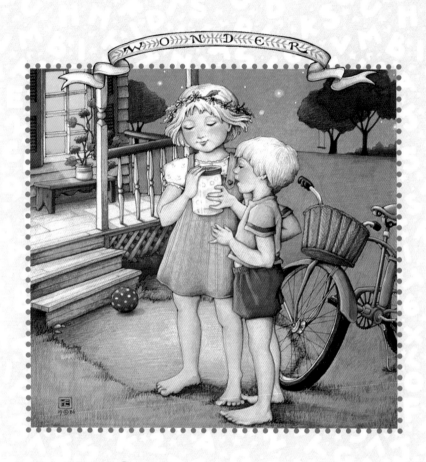

Teaching is the art of sharing.

–Abraham Joshua Heschel

by learning you will teach; by teaching you will learn *Latin proverb* to be ab
to be caught up into the world
thought — that is to be educated *Ea*
*Hamilton* we can be wise from goodne
and good fr... *Marie von Ebn*
*Eschenbach* the ... of learnir
separates youth from old age.
long as you're learning, you're n
old *Rosalyn S. Yalow* education's purpose
to replace an empty mind with a
open one *Malcolm Forbes* to believe you
own thought, to believe that what
true for you in your private heart
true for all men—that is genius

**LEARN AND LIVE**

...from life

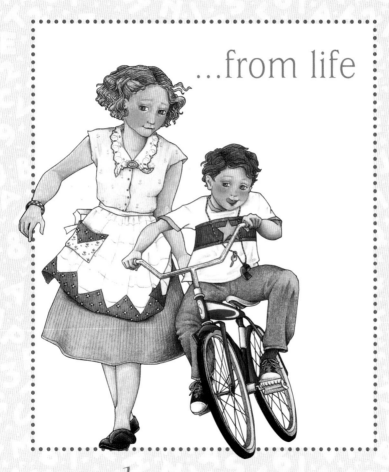

Learn to teach yourself.

- anonymous

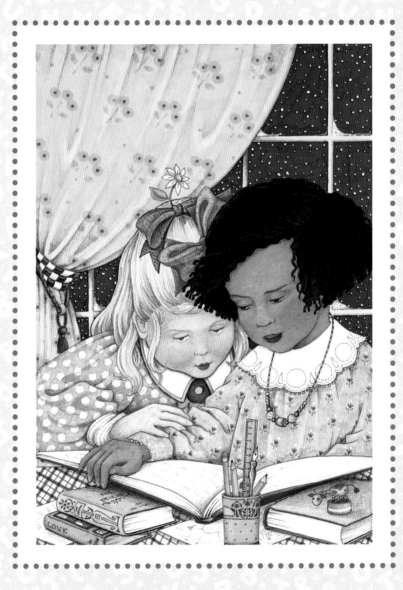

> *Our fundamental task*
> *as human beings*
> *is to seek out connections*
> *to exercise our imaginations.*
> *It follows, then, that the*
> *basic task of education*
> *is the care and feeding*
> *of the imagination.*
> *—Katherine Paterson*

Imagination is more important than knowledge.
Knowledge is limited.
Imagination encircles the word.
—Albert Einstein

Let the teacher go into a village
and take part in the crafts
which are being practiced there
along with his pupils.
—Vinoba Bhave

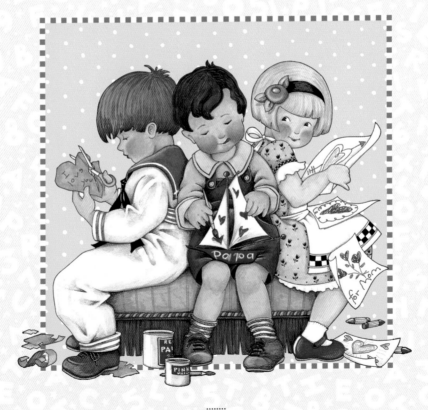

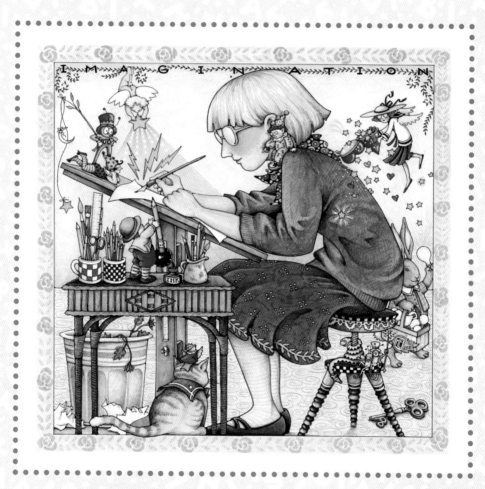

To be able to be caught up
into the world of thought—that is to be educated.
—Edith Hamilton

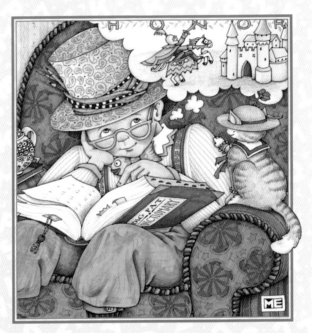

To believe your own thought,
to believe that what is true for you in your private heart
is true for all men—that is genius.
—Ralph Waldo Emerson

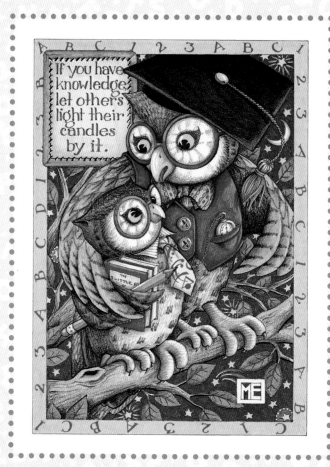

If you have knowledge, let others light their candles by it.

We can be wise from goodness and good from wisdom.

–Marie von Ebner-Eschenbach

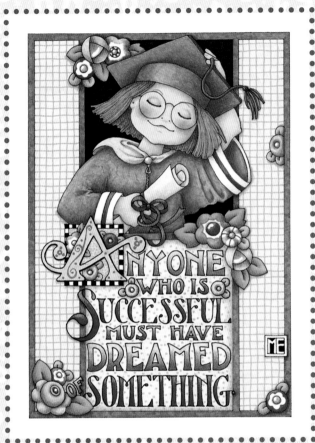

Education is not received.
It is achieved.

—anonymous

Education is a social process...
Education is growth...
Education is, not a preparation for life;
education is life itself.

–John Dewey

Let us think of education
as the means of developing our greater abilities,
because in each of us there is a private hope
and dream which, fulfilled, can be translated
into benefit for everyone
and greater strength for our nation.

–John F. Kennedy

Education's purpose
is to replace an empty mind
with an open one.
—Malcom Forbes

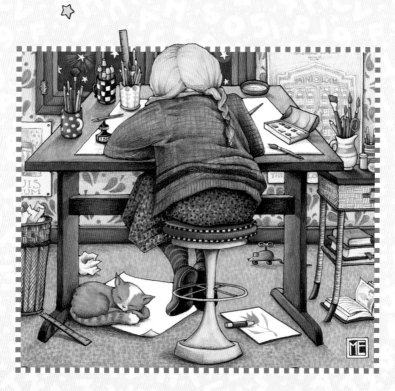

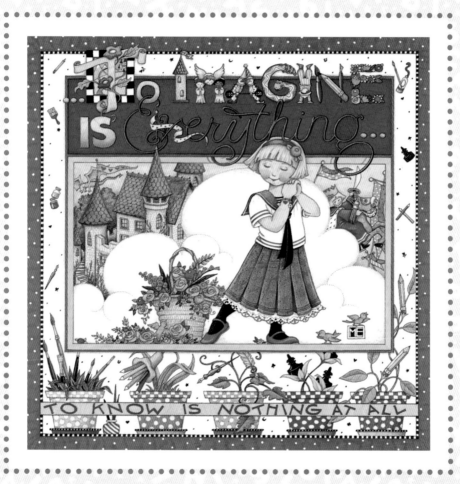

The aim
of education
is the knowledge
not of facts
but of values.
–Dean William
Ralph Inge

GOOD
THINKING

Children must be taught how to think, not what to think.

–Margaret Mead

The excitement of learning
separates youth from old age.
As long as you're learning,
you're not old.
–Rosalyn S. Yalow

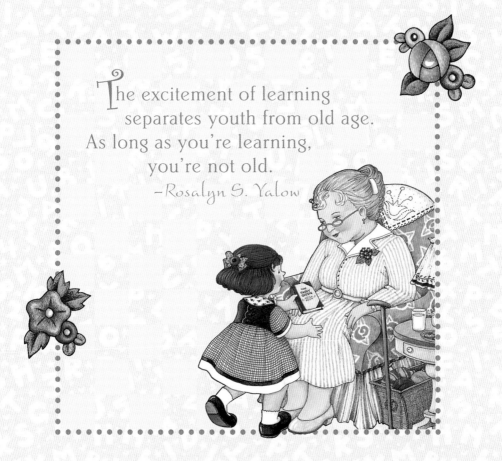

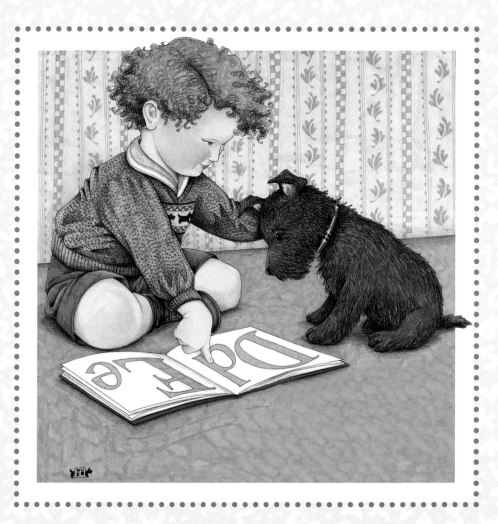

In teaching others
we teach ourselves.
–proverb

Learning is a treasure
that will follow its owner
everywhere.
–Chinese proverb

It's what you learn after you know it all that counts.
–Judith Kelman

*By learning
you will teach;
by teaching
you will learn.*

*—Latin proverb*

If there's a single message passed down
from each generation of American parents
to their children, it is a one-word line.
Better yourself.
And if there's a temple of self-betterment
in each town, it is the local school.
We have worshiped there for some time.
—Ellen Goodman

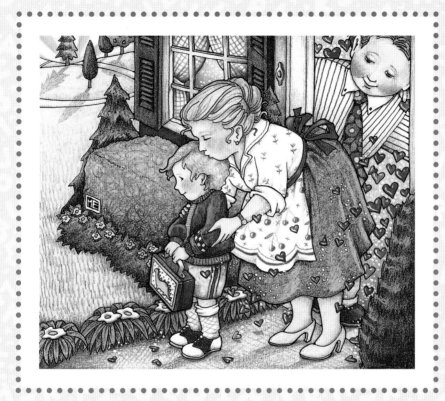

*A* human being is not attaining his full
heights until he is educated.

–Horace Mann

teachers open the door, but you

teacher is one who makes two ide

Elbert Hubbard a schoolmaster should h

wonderingly, as if he was amazed

garden, an orchard, a storehouse

counselor, a multitude of counselors

friends, the same today and forev

the laps of their parents Emilie Buchwald

is your teacher Ken Keyes, Jr. nature ha

remember, a source of solace, ir

home, a teacher, a companion Lo

separates youth from old age. as l

Rosalyn S. Yalow to be able to be caught u

be educated Edith Hamilton the unknow

the field for his life's adventure. a